The Wonder of Girls

the world through the eyes of girls

· Karen Henrich ·

CUMBERLAND HOUSE
NASHVILLE, TENNESSEE

THE WONDER OF GIRLS
PUBLISHED BY CUMBERLAND HOUSE PUBLISHING
431 Harding Industrial Drive
Nashville, Tennessee 37211

Cover design: James Duncan Creative
Book design: Mary Sanford

ISBN-13: 978-1-58182-611-1
ISBN-10: 1-58182-611-7

Printed in Canada
2 3 4 5 6 7—13 12 11 10 09 08

Coming from the place of having two boys, I want to dedicate this book to all of the little girls in my life who share with me their little girl dreams, let me come to their dress-up birthday parties, and give me my fill of hugs.

I believe that all children are full of the same wonder of the world. A child's spirit does not hide, even in illness. To that end, I have started a non-profit foundation, Moment by Moment, which captures images of terminally ill children. A cadre of professional photographers donate their time to work with the foundation to capture these precious and fleeting images. Families of these children receive a photography session with one of these professional photographers, a set of black and white matted images, and a DVD of the session, all at no cost to the family.

A percentage of the proceeds from this book will go directly to the Moment by Moment Foundation to ensure that as many families as possible receive this gift.

Acknowledgments

I appreciate all of the little girls in my life, who freely share with me their thoughts, hopes, and dreams. To my nieces and all of my little girlfriends, thank you for being such an important part of my life; you bring me such joy. Sincere appreciation also goes to their mothers, my friends; your strength and consistent friendship inspires me. Genuine thanks also goes to Ron Pitkin, my publisher, and Mary Sanford for sharing the idea that the wonder of these little girls should be shared with others. And of course, to the most important boys in my life, my husband Scott and my sons Chris and Mason, the three of you keep MY world filled with wonder, and I am forever grateful.

It was once said, "Sugar and spice and everything nice, that's what little girls are made of." As a photographer behind the lens, capturing images of many girls, I assure you they are all of this and much more. I believe that I see a little girl's world from a different perspective, from the inside out. . . . Now, that may seem a bit curious, because being a photographer, one would think that what I see is what is printed from the image I have captured. You would assume that I see smiles, giggles, pouts, and tears. I do see these expressions in the pictures that I take, but also, in that snapshot of their lives, I see a glimpse of that girl's soul.

A girl's world is filled with wonder when she sees a caterpillar turn into a butterfly. A girl's soul is illuminated when she sees the first flowers blooming in the spring. Her soul is filled with joy when she interacts with family and friends.

It is my hope that while looking at the images on the pages that follow, you will pause for a moment and allow your soul to feel the joy, the fascination, and the wonderment that these girls experienced when I caught them on film. Sometimes, as we are moving from one "significant event" to another, we miss out on the "little things," the moments that engage us in a sense of appreciation of our unique world.

It is because of this that I invite you to again revisit the world of a child, seen through the eyes of these little girls, and may you have a renewed sense of appreciation for the little moments that we may often miss.

Enjoy the journey.

The Wonder of Girls

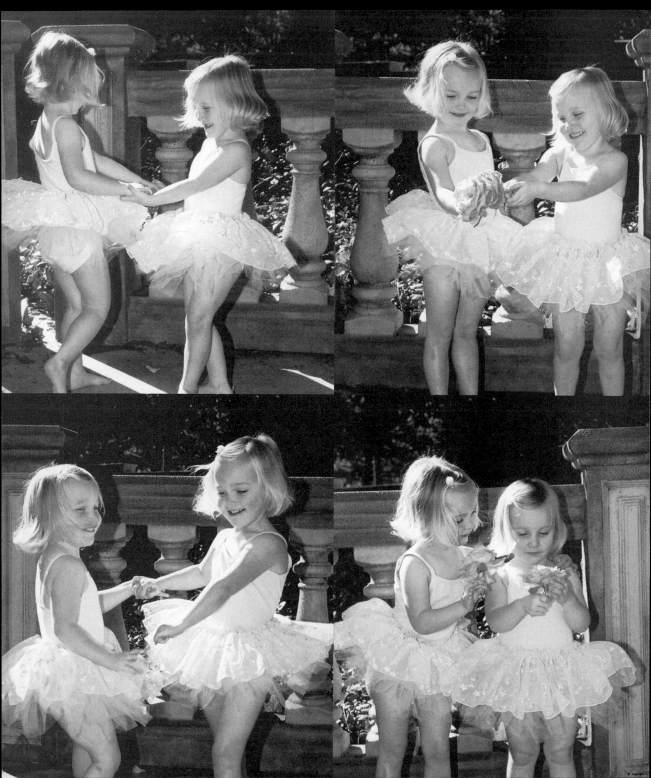

Of two sisters, one is always the watcher, one the dancer.

[LOUISE GLÜCK]

Childhood has its own way of seeing, thinking and feeling, and nothing is more foolish than to try and substitute ours for theirs.

[JEAN JACQUES ROUSSEAU]

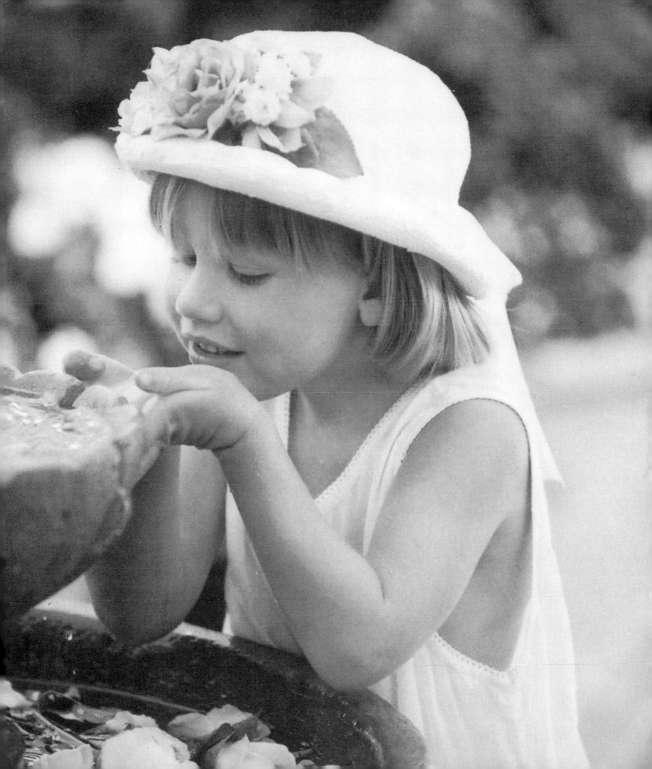

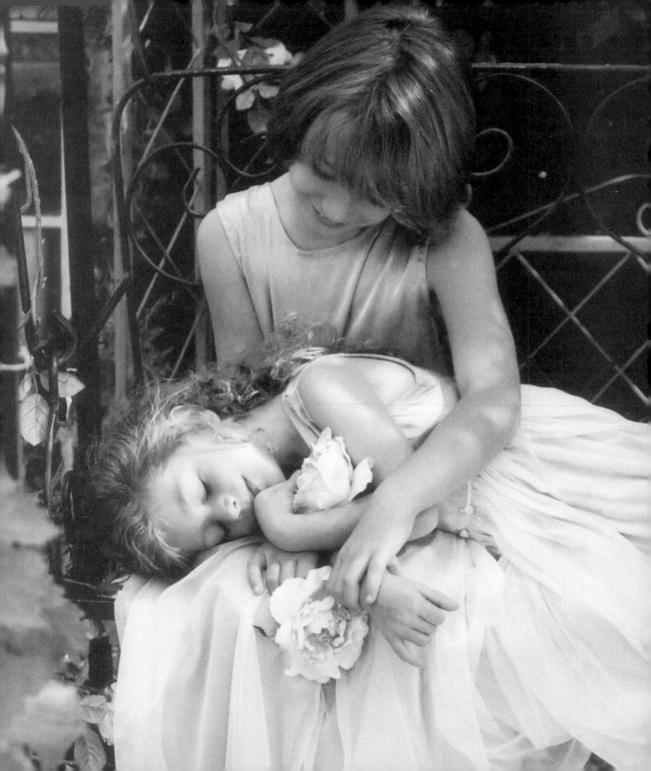

Sisters share the scent and smells—
the feel of a common childhood.

[PAM BROWN]

Today
my baby
went from a little girl
to a little lady.

[MONIQUE MIXON]

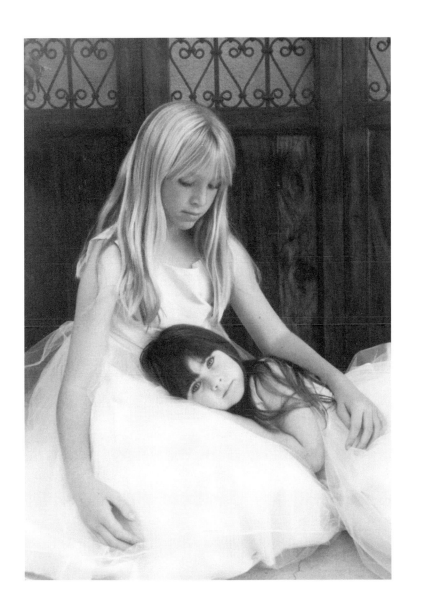

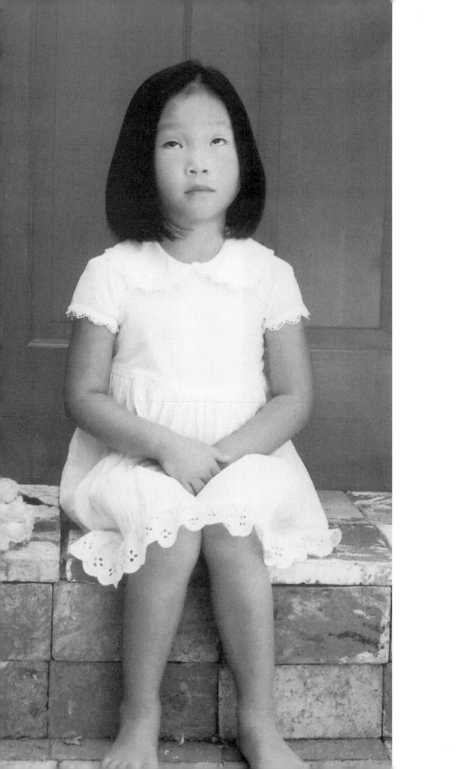

Grownups never understand anything for themselves. And it is tiresome for children to always and forever be explaining things to them.

[ANTOINE DE SAINT-EXUPÉRY, *THE LITTLE PRINCE*]

I have found the best way to give advice to your children is to find out what they want and then advise them to do it.

[HARRY S TRUMAN]

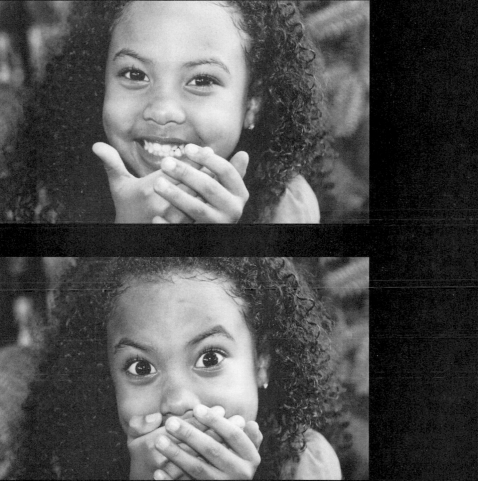

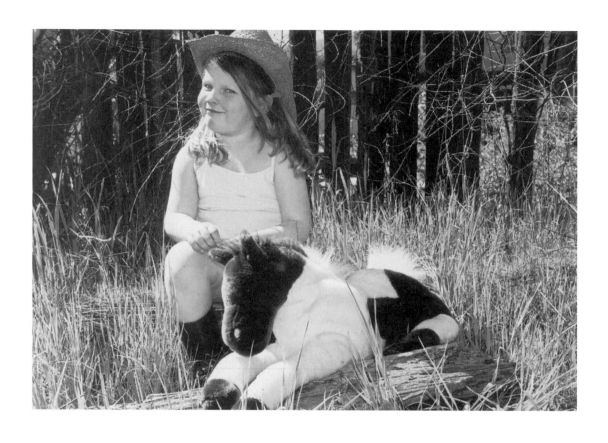

The greatest poem ever known
Is one all poets have outgrown:
The poetry, innate, untold,
Of being only four years old.

[CHRISTOPHER MORLEY]

The average child laughs 400 times per day,
the average adult 15 times. . . .

What happened to the other 385 laughs?

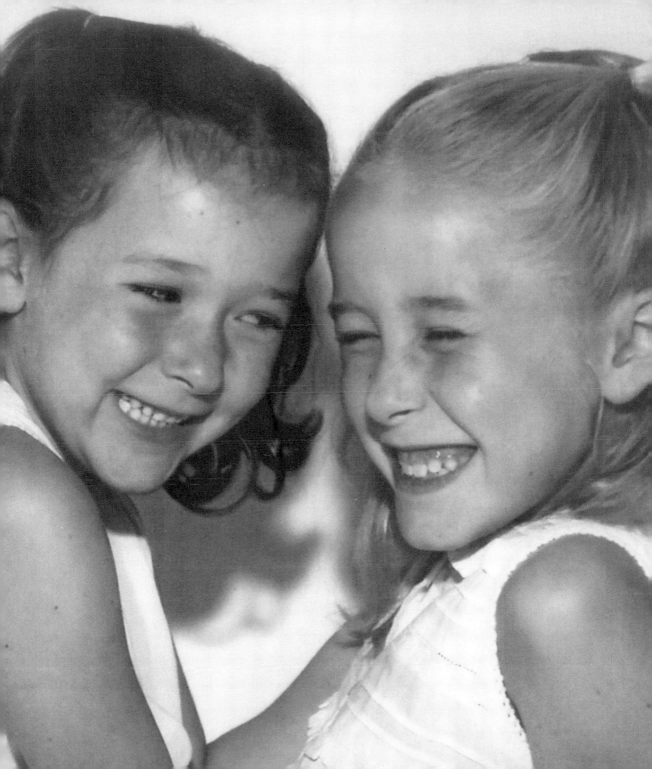

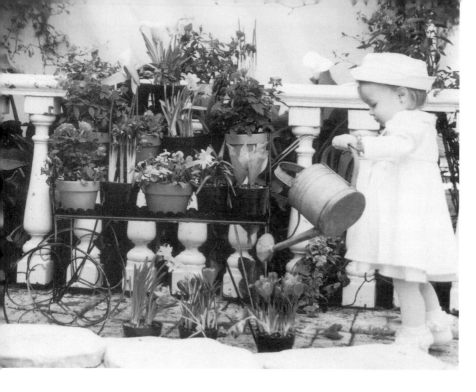

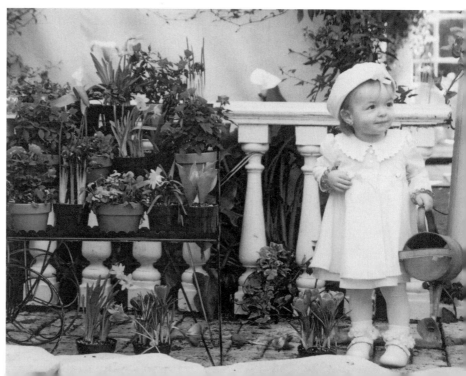

Scatter joy.

[RALPH WALDO EMERSON]

Within your heart,
keep one still, secret spot
where dreams may go.

[LOUISE DRISCOLL]

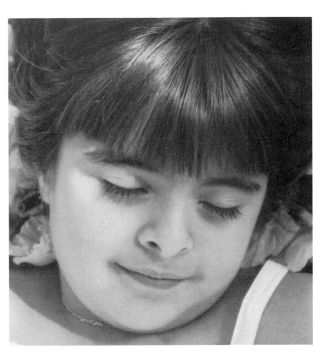

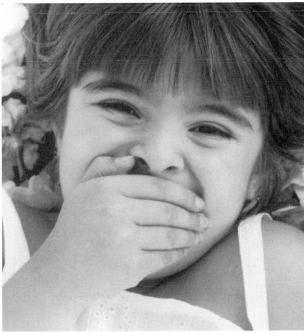

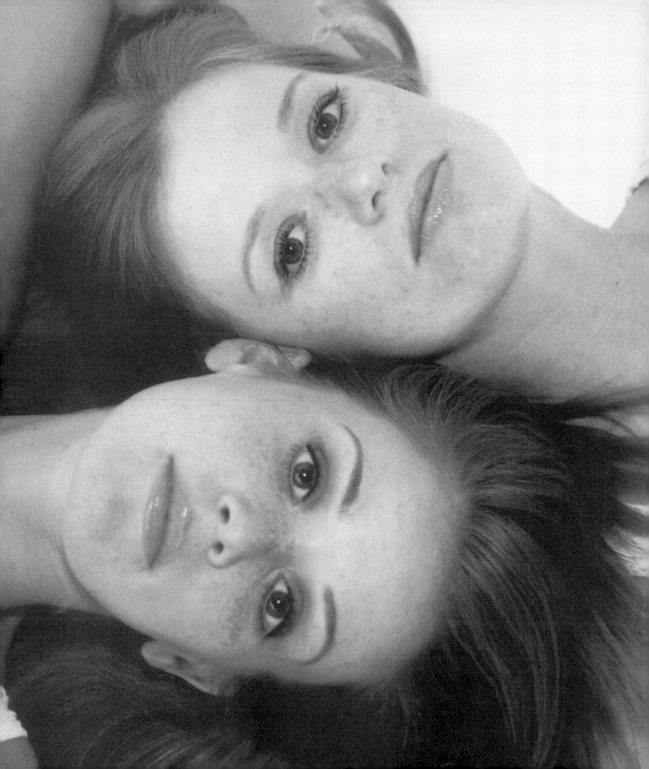

A sister shares childhood memories and grown-up dreams.

[UNKNOWN]

There was a little girl,
Who had a little curl,
Right in the middle of her forehead.

When she was good,
She was very good indeed,
But when she was bad she was horrid.

[HENRY WADSWORTH LONGFELLOW]

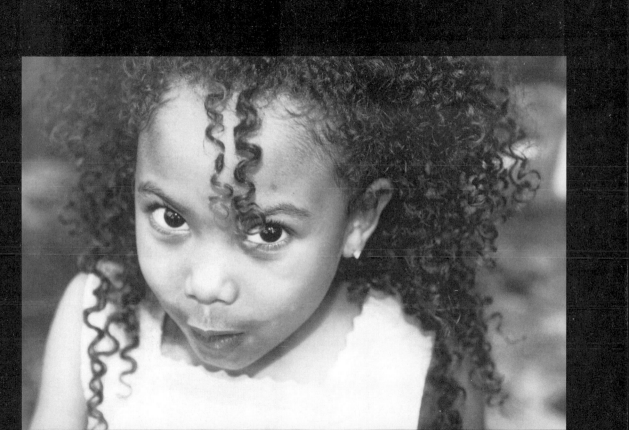

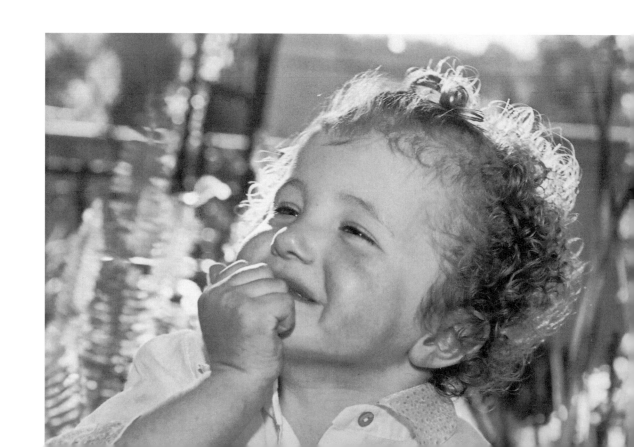

The knowingness of little girls,
hidden underneath their curls.

[PHYLLIS MCGINLEY]

A child is a curly, dimpled lunatic.

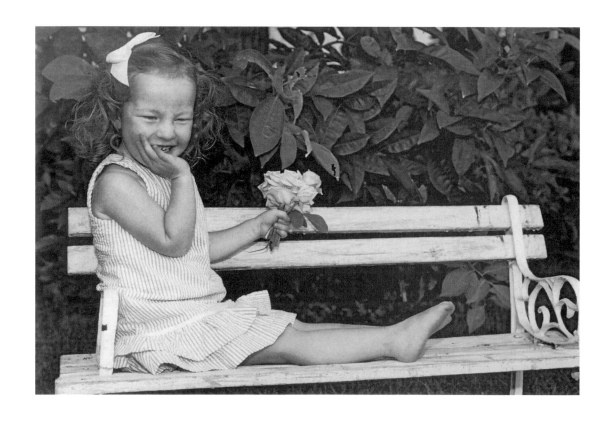

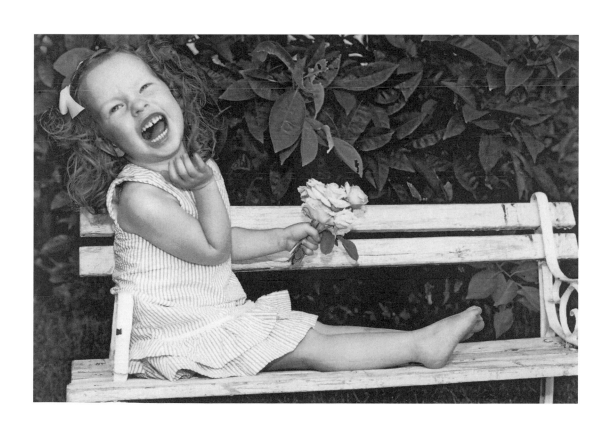

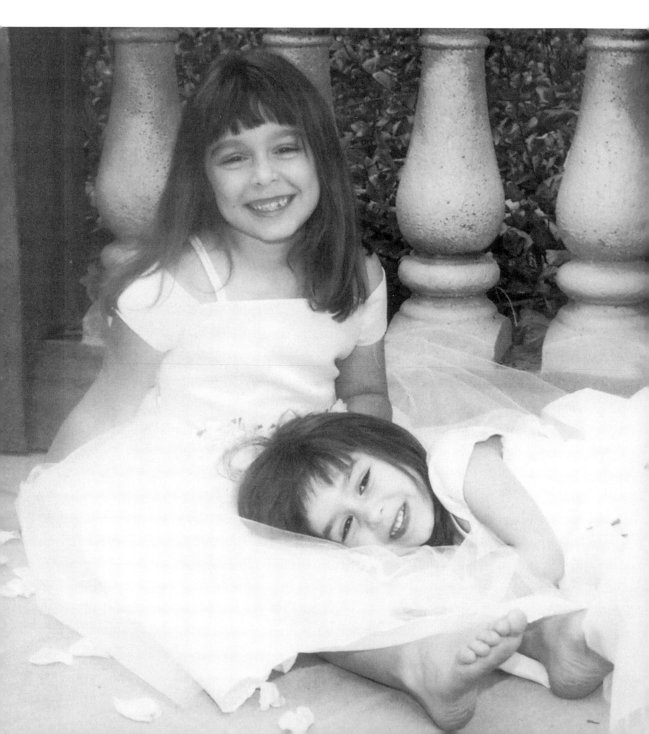

Childhood is the most beautiful of all life's seasons.

[UNKNOWN]

Children in a family are like flowers in a bouquet:
there's always one determined to face in an opposite
direction from the way the arranger desires.

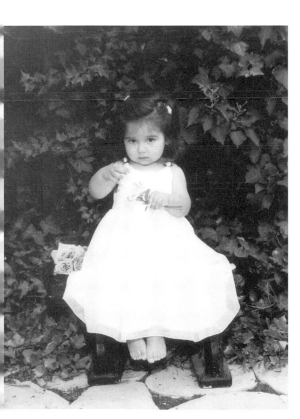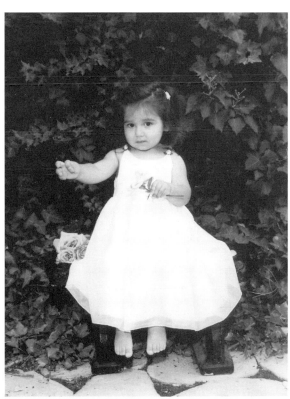

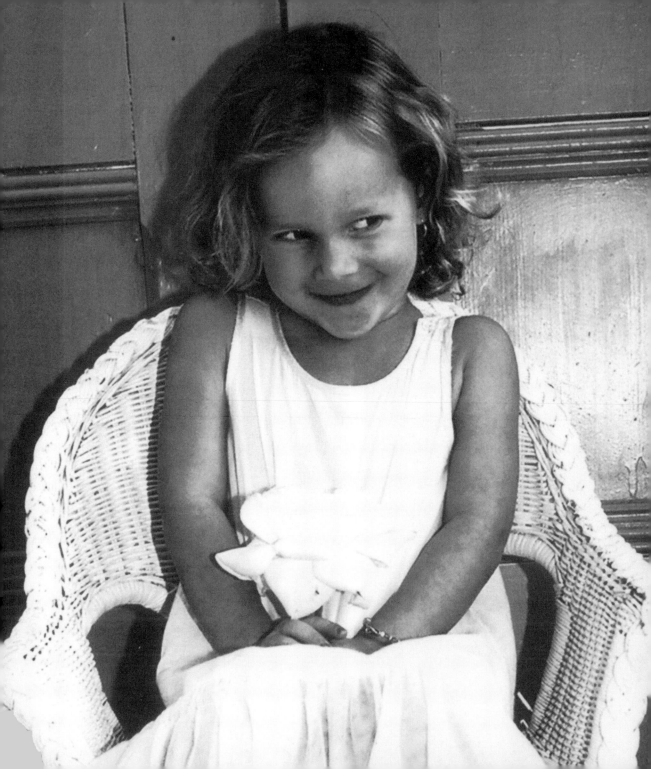

Little girls, like butterflies, need no excuse.

[ROBERT A. HEINLEIN]

While we try to teach our children all about life,
our children teach us what life is about.

[ANGELA SCHWINDT]

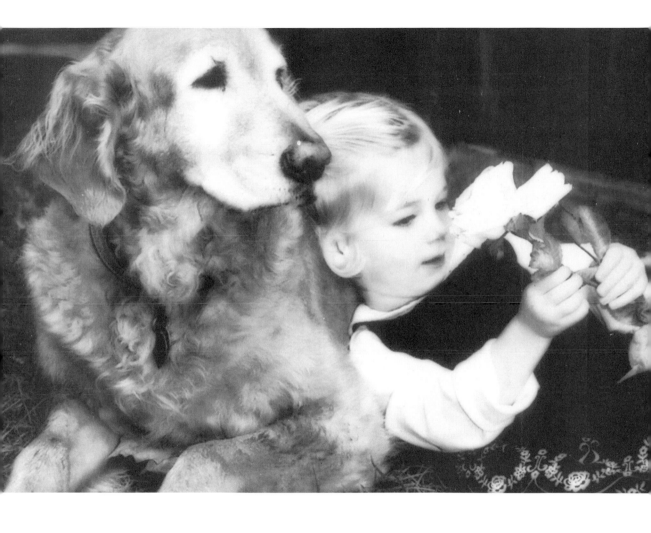

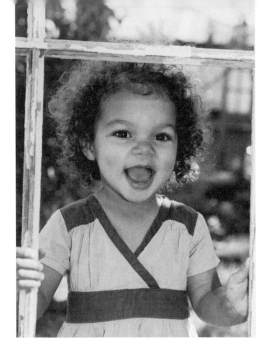
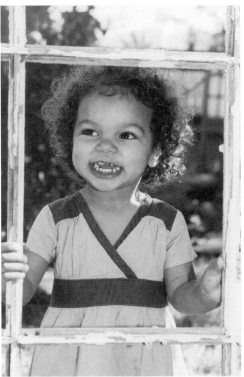
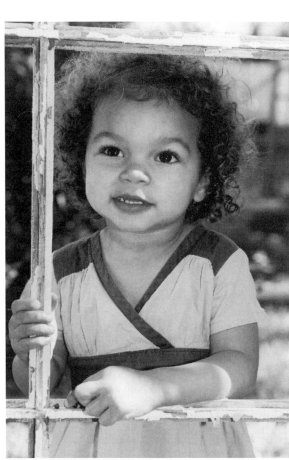

Those who bring sunshine to the lives of others cannot keep it from themselves.

[J. M. BARRIE]

She has the spirit of the sun,
the moods of the moon,
the will of the wind.

[JULIE PERKINS CANTRELL]

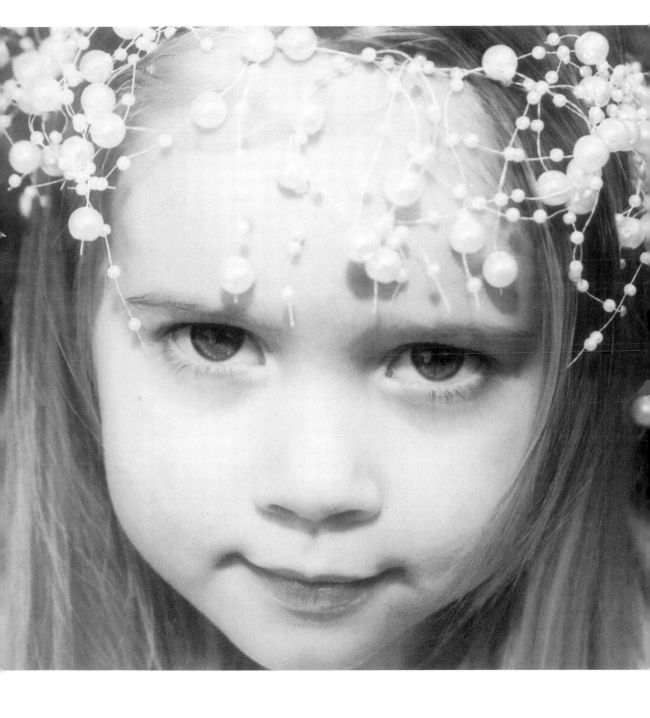

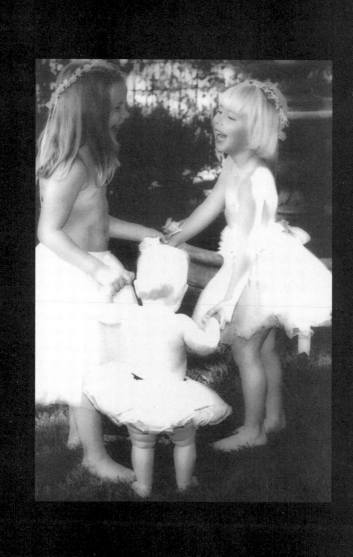

Little girls dance their way into your heart, whirling on the tips of angel wings, scattering gold dust and kisses in our paths.

[UNKNOWN]

A sister is a little bit of childhood that can never be lost.

[MARION C. GARETTY]

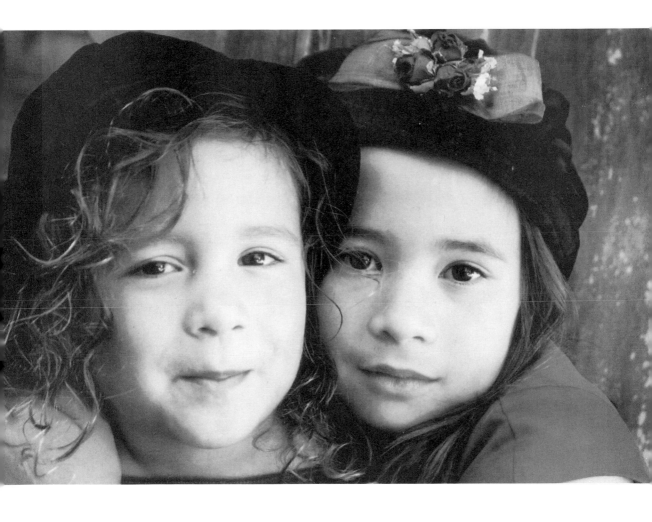

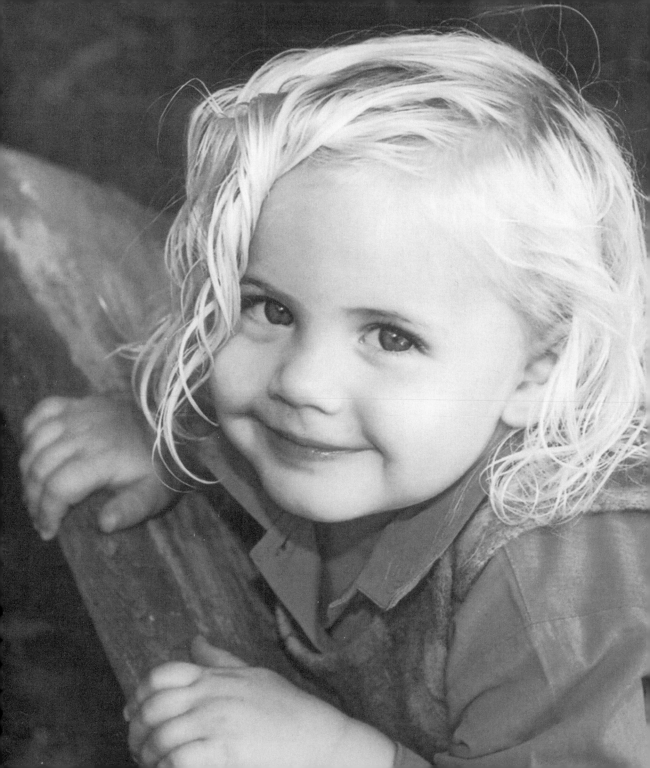

Oh! Little lock of golden hue,

In gently waving ringlet curl'd,

By the dear head on which you grew,

I would not lose you for the world.

[LORD BYRON]

A daughter is the happy memories of the past, the joyful moments of the present, and the hope and promise of the future.

[UNKNOWN]

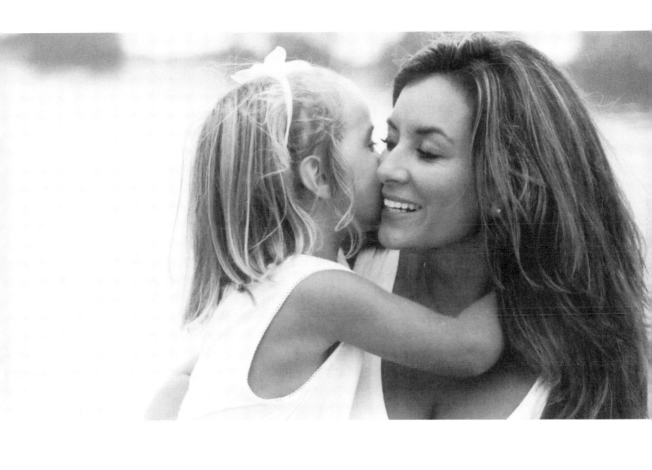

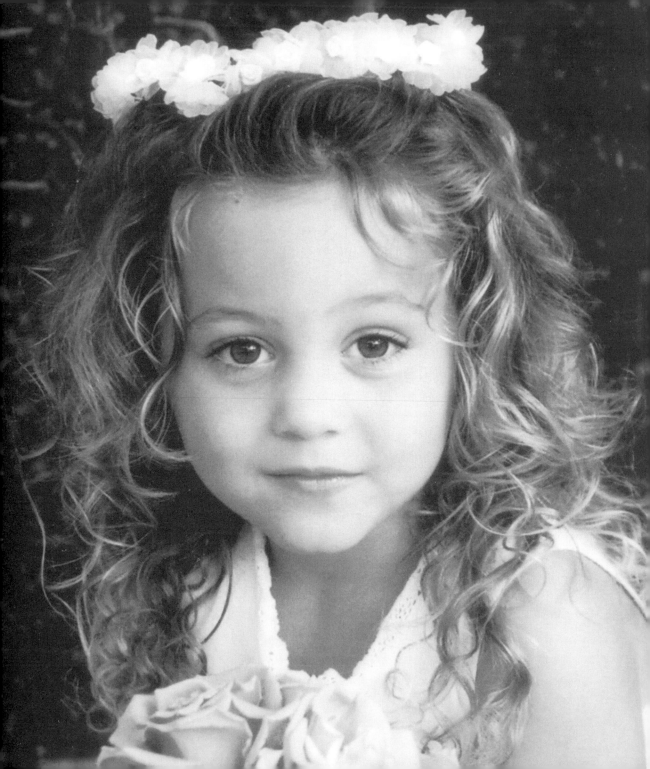

We must teach our children to dream with their eyes wide open.

[HARRY EDWARDS]

There is always one moment in childhood
when the door opens and lets the future in.

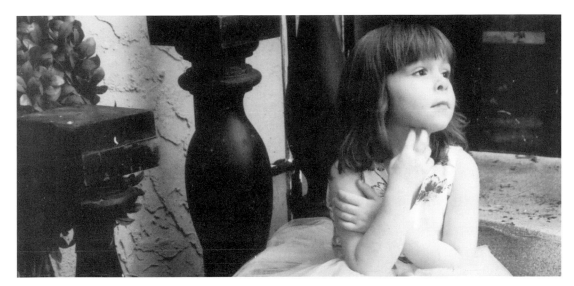

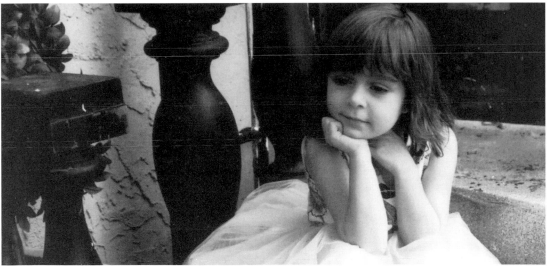

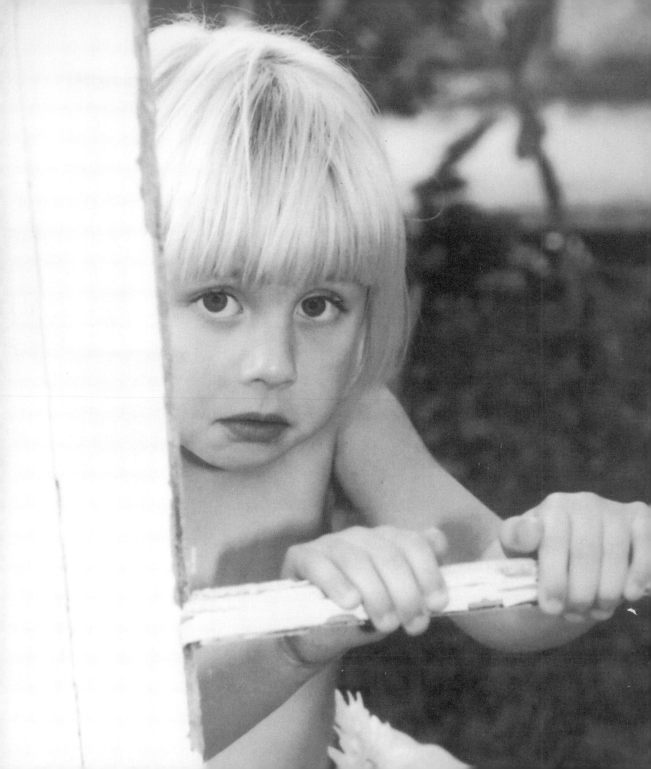

No one has yet fully realized the wealth
of sympathy, kindness and generosity
hidden in the soul of a child.

[EMMA GOLDMAN]

A daughter may outgrow a father's lap, but she will never outgrow his heart.

[UNKNOWN]

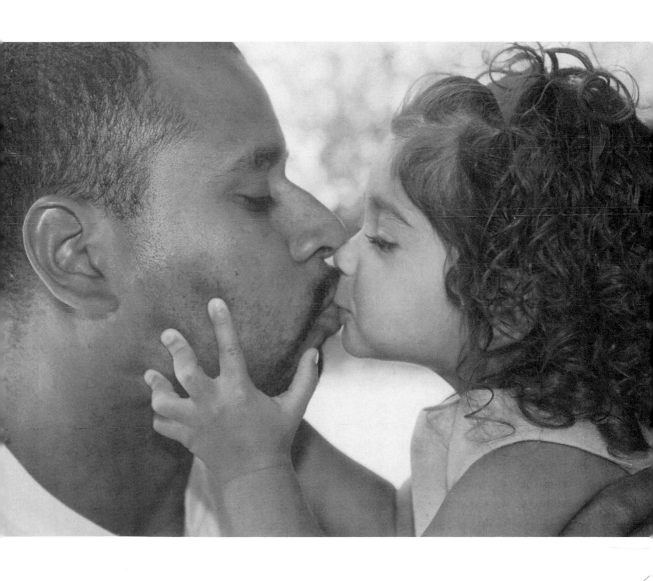

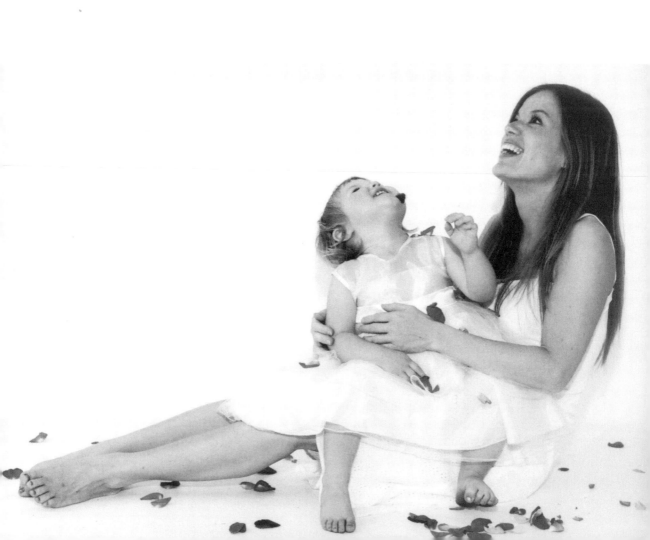

Making the decision to have a
child—it's momentous. It is to
decide forever to have your heart
go walking outside your body.

[ELIZABETH STONE]

Children find everything in nothing;
men find nothing in everything.

[GIACOMO LEOPARDI]

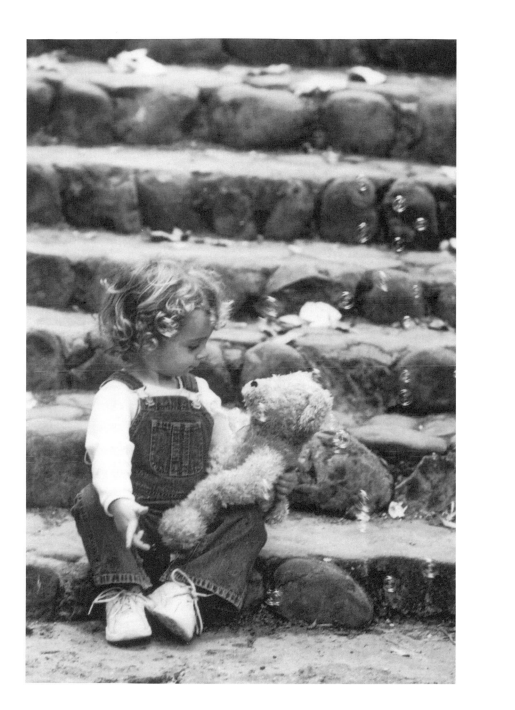

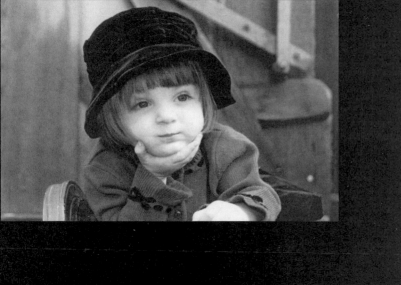

It is not easy to be crafty and winsome at the same time, and few accomplish it after the age of six.

[JOHN GARDNER]

Sisters are different flowers from the same garden.

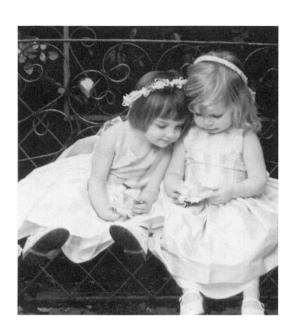
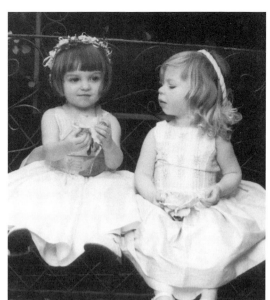
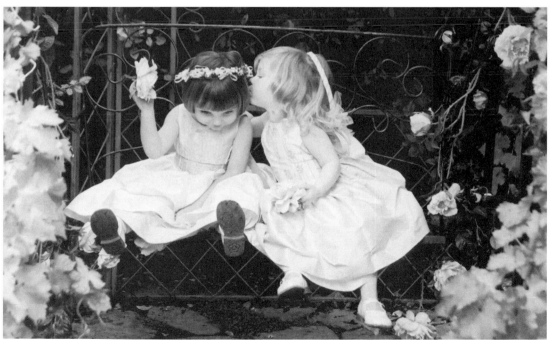

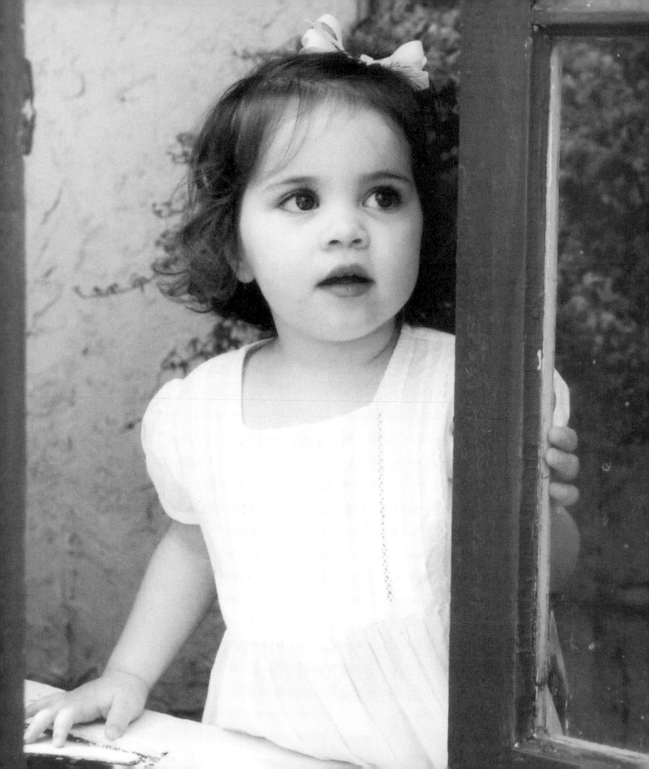

There is a garden in every childhood, an enchanted place where colors are brighter, the air softer, and the morning more fragrant than ever again.

[ELIZABETH LAWRENCE]

The future belongs to those who believe in the beauty of their dreams.

[ELEANOR ROOSEVELT]

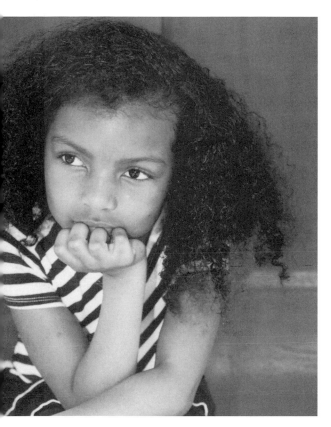
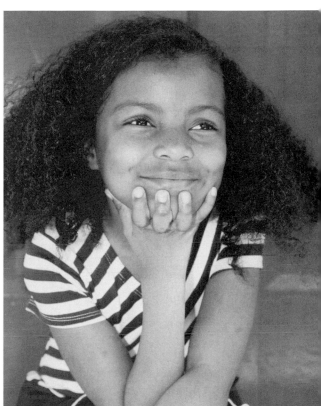

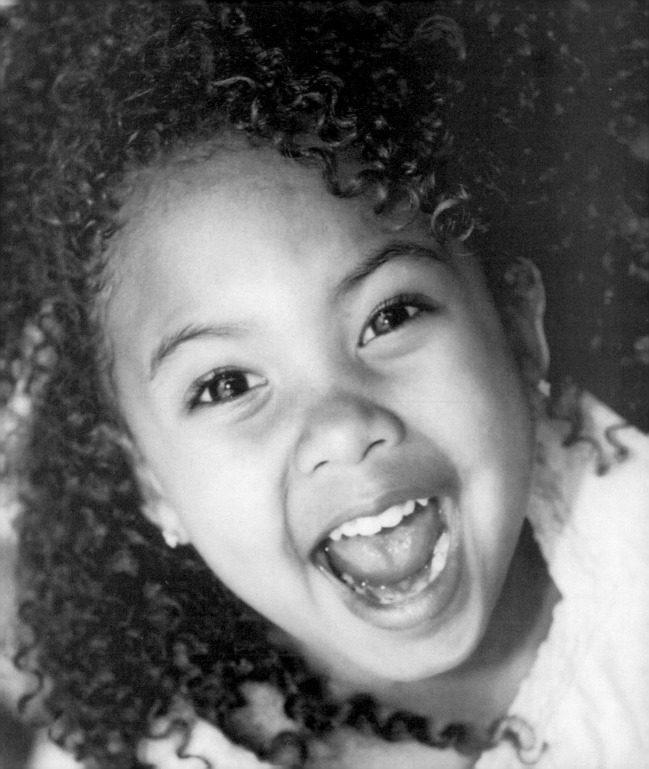

A girl is innocence playing in the mud,
beauty standing on its head,
and motherhood dragging a doll by the foot.

[ALAN BECK]

The perfect shoes can change your life.

[CINDERELLA]

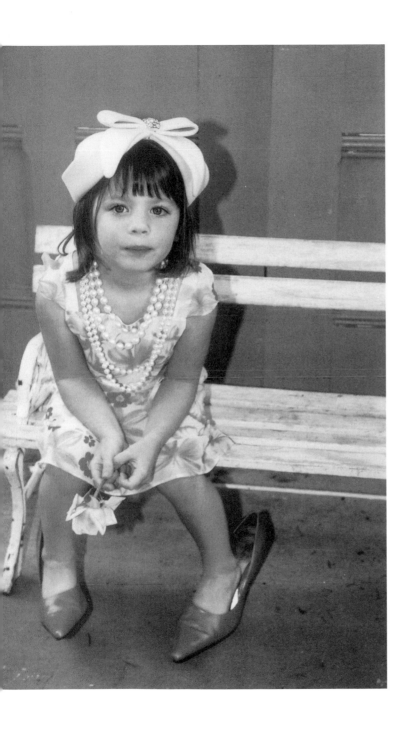

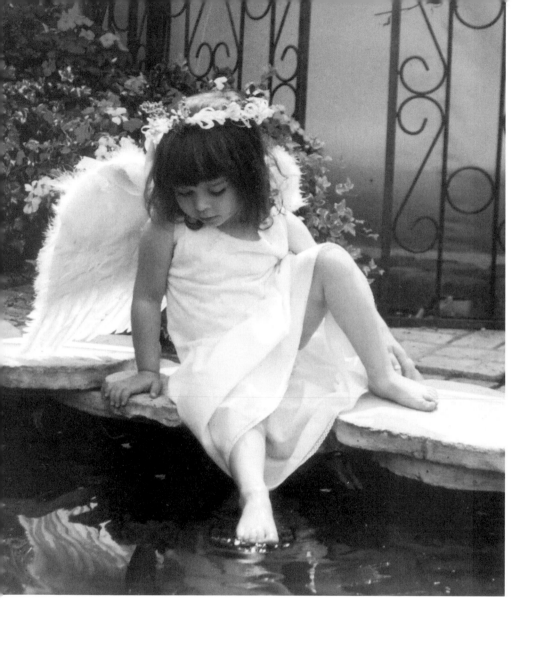

Little girls are the nicest things that happen to people. They are born with a little bit of angelshine about them, and though it wears thin sometimes there is always enough left to lasso your heart.

[ALAN BECK]

It is rare that one can see in a
little boy the promise of a man,
but one can almost always see in
a little girl the threat of a woman.

[ALEXANDRE DUMAS]

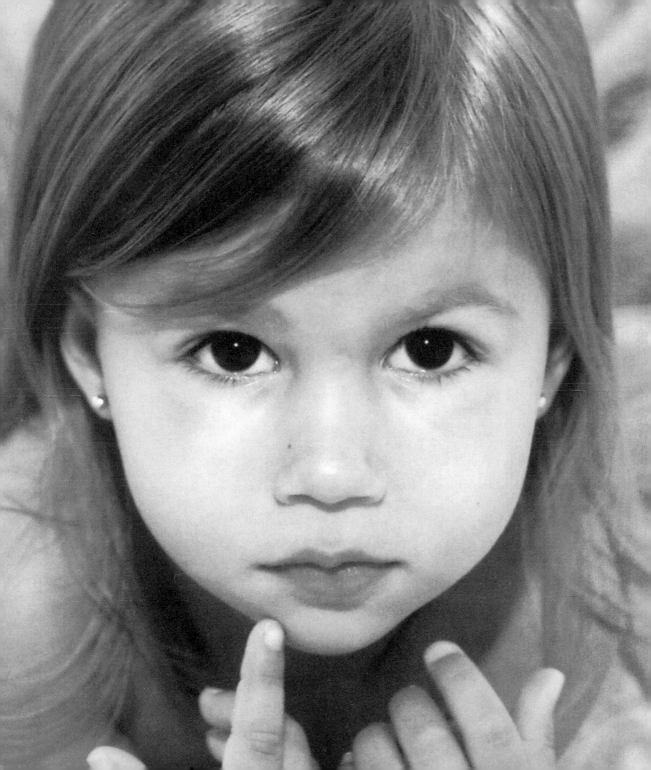

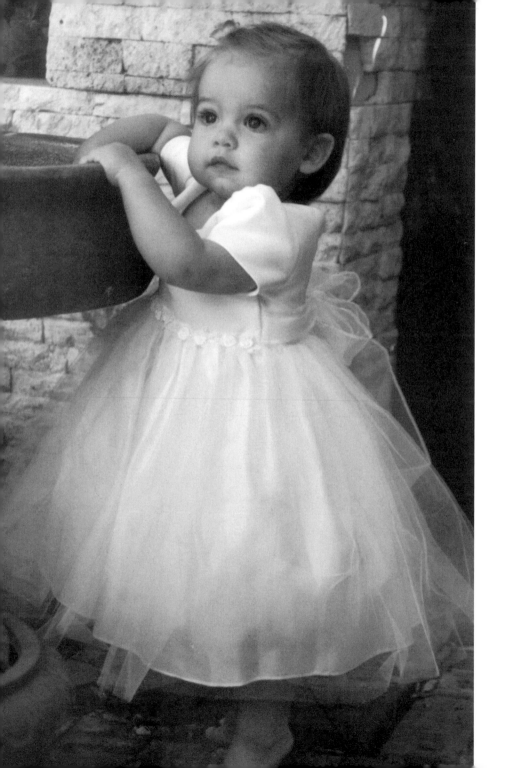

The beauty of a girl cannot be mimicked, fabricated, or created by human means; it only occurs naturally.

[PAM CALLAGHAN]

Little girls are precious gifts wrapped in love serene. Their dresses tied with sashes and futures tied with dreams.

[UNKNOWN]

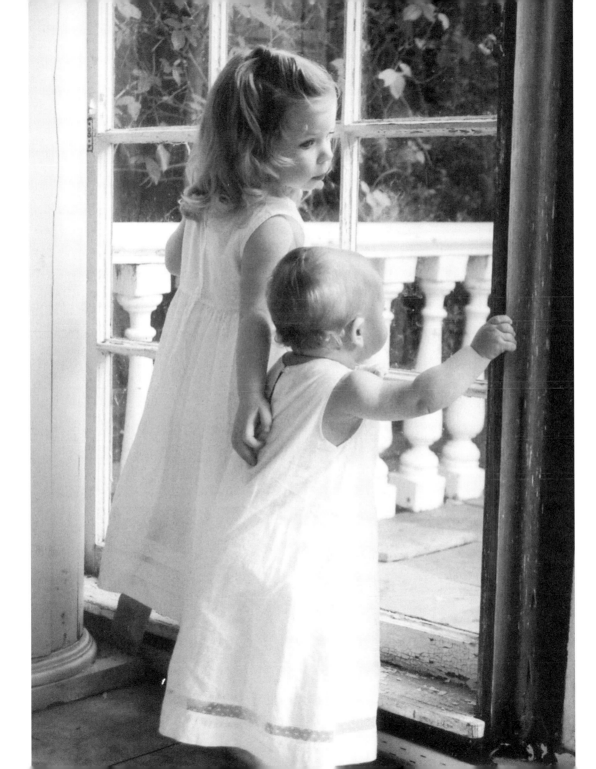

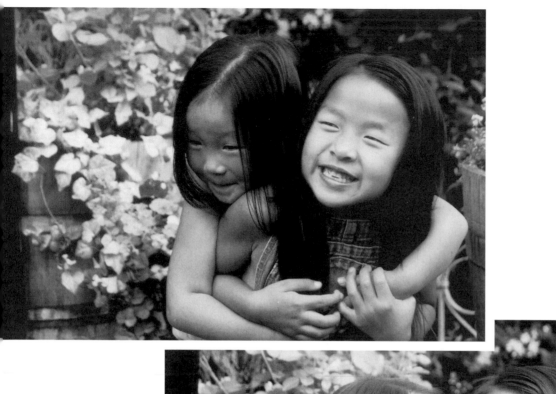

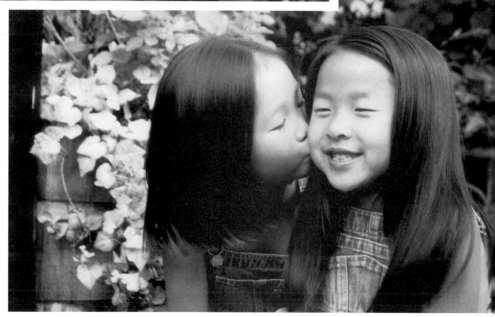

A sister is a gift to the heart,
a friend to the spirit,
a golden thread to the meaning of life.

[ISADORA JAMES]

What the daughter does, the mother did.

[JEWISH PROVERB]

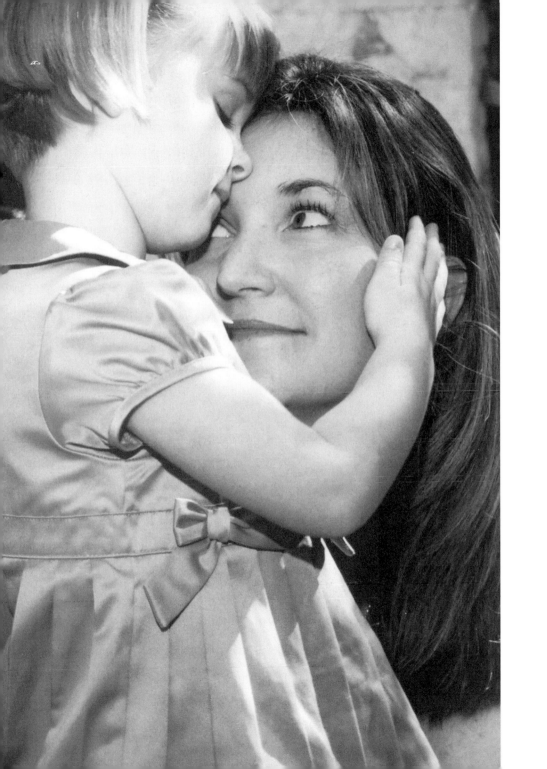

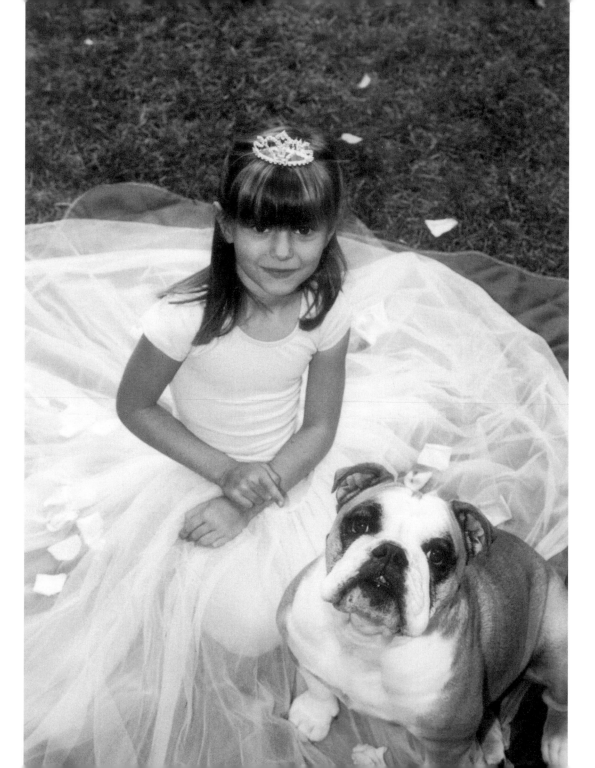

There is a place in childhood I remember well,
and there a voice of sweetest tone, bright fairy tales did tell.

[SAMUEL LOVER]

More than Santa Claus, your sister knows when you've been bad and good.

[LINDA SUNSHINE]

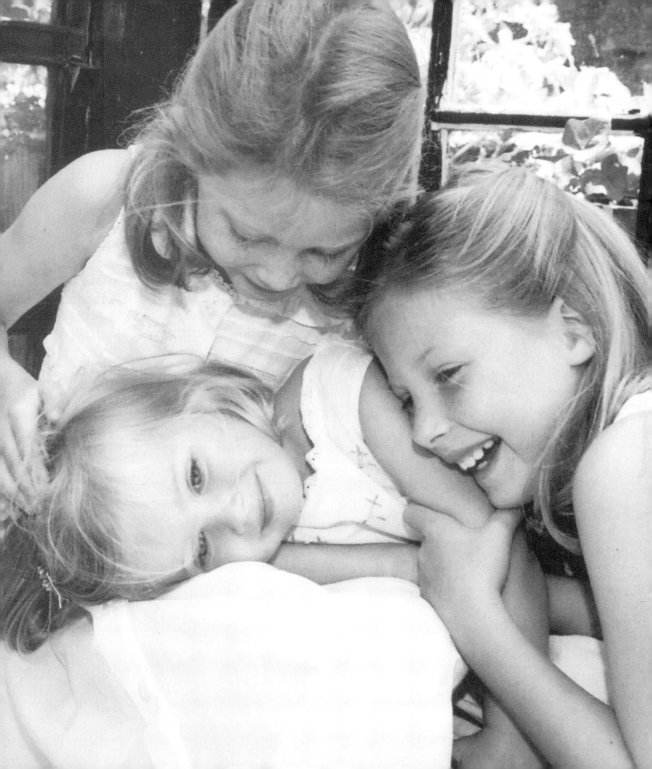

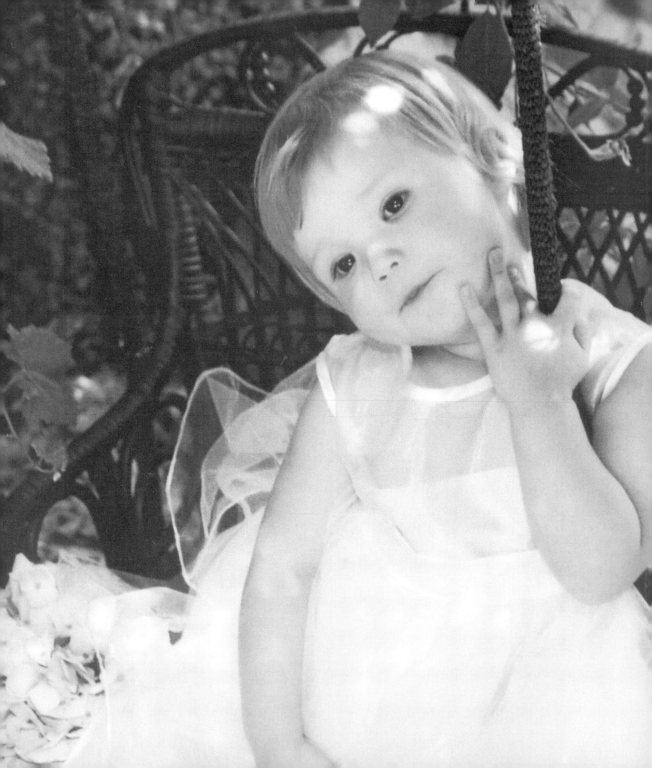

Now and then it
is good to pause
in our pursuit of
happiness and
just be happy.

[ANONYMOUS]

We find a delight in the beauty and happiness of children that makes the heart too big for the body.

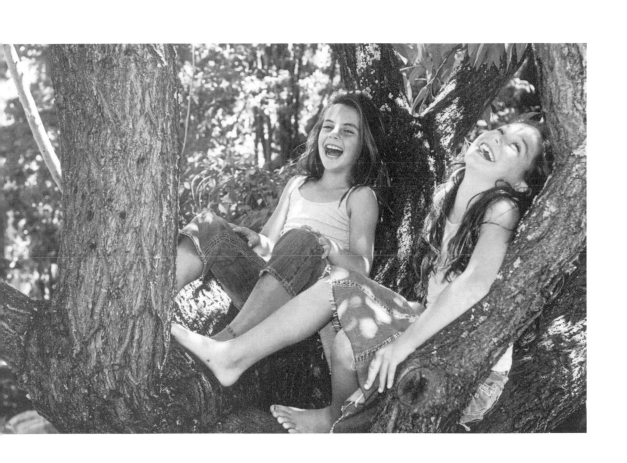

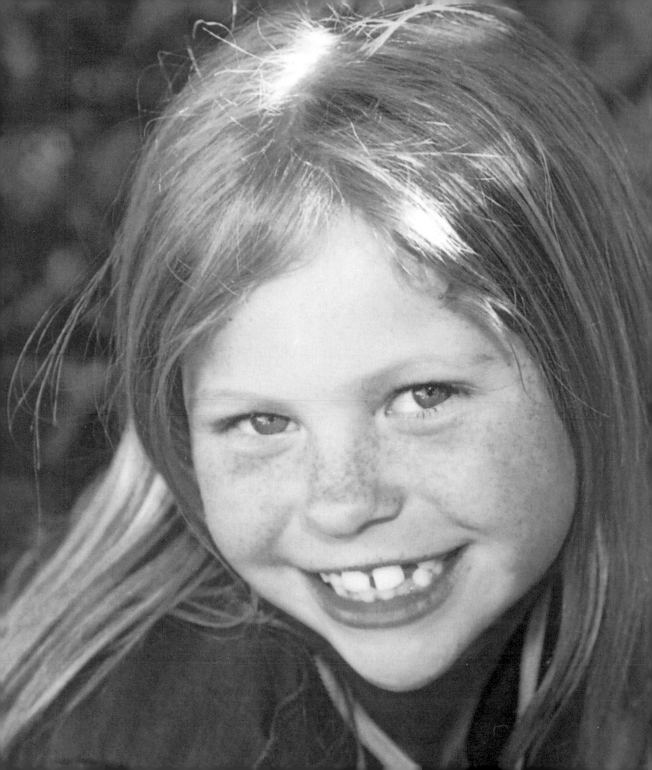

Girls are giggles with freckles all over them.

[UNKNOWN]

A toddling little girl is a center of common feeling which makes the most dissimilar people understand each other.

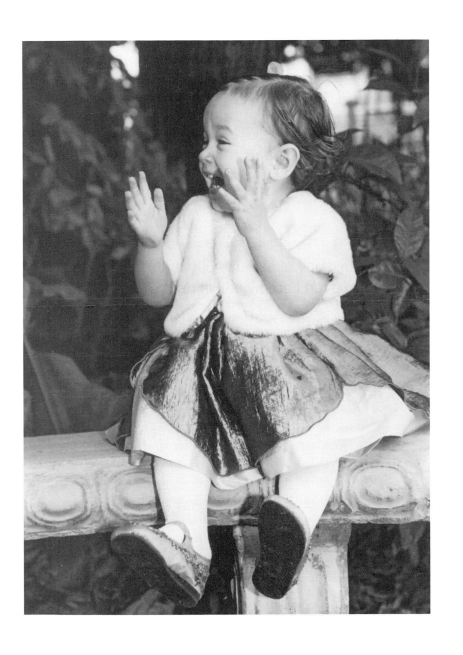

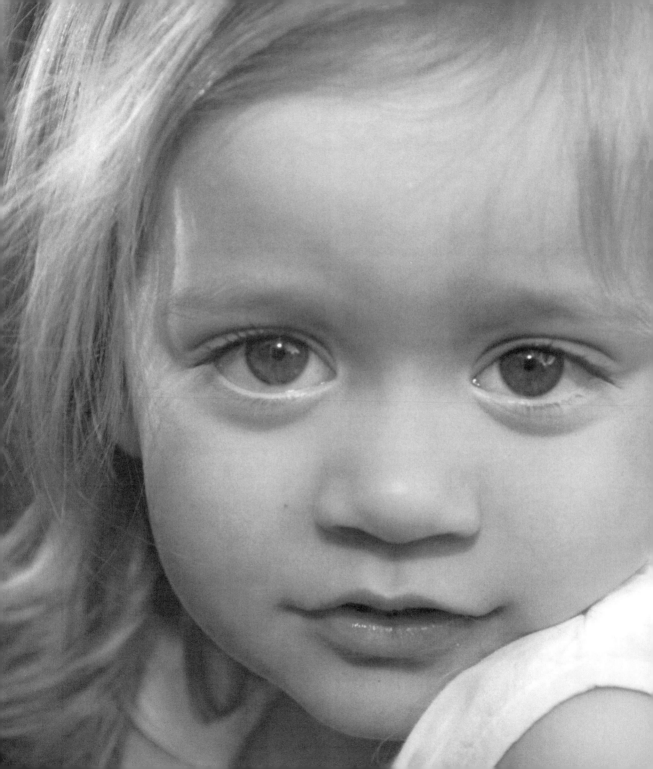

What is it that you express in your eyes?
It seems to me more than all the words I have read in my life.

[WALT WHITMAN]

It is the sweet, simple things of life which are the real ones after all.

[LAURA INGALLS WILDER]

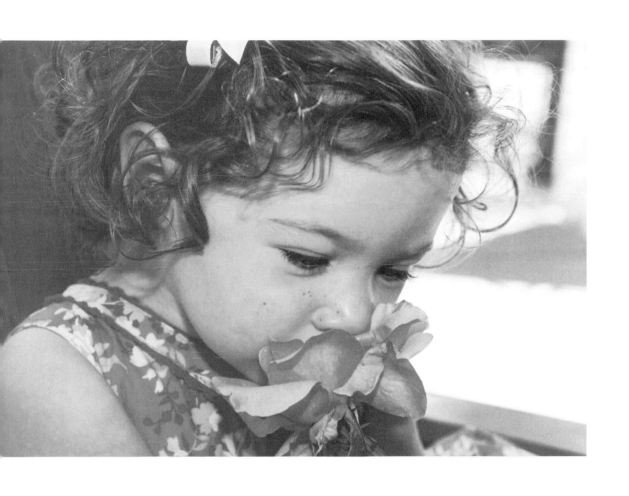

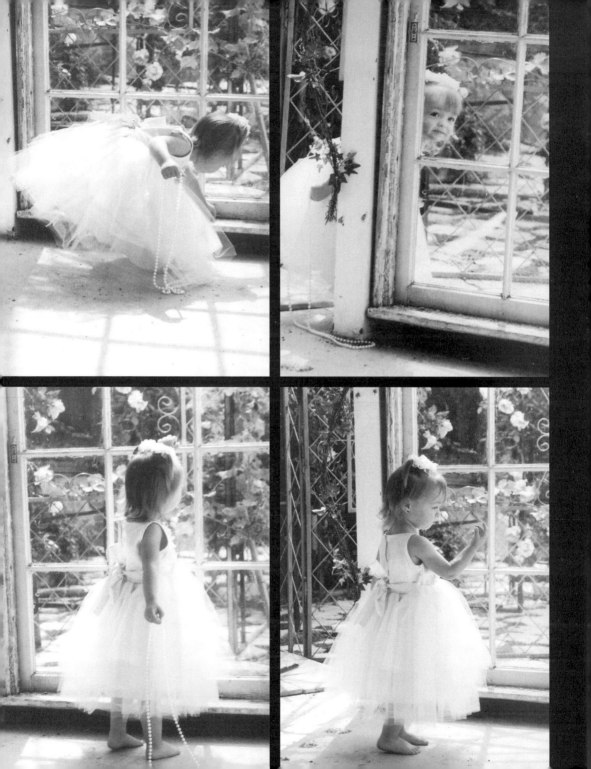

We should stop and gaze at the
beauty of a child's wonder.

[ANONYMOUS]

The laughter of girls is, and ever was,
among the delightful sounds of the earth.

[THOMAS DE QUINCEY]

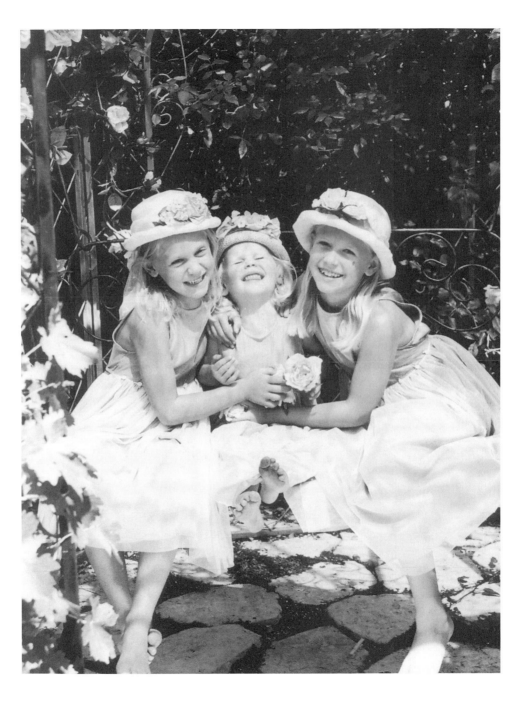

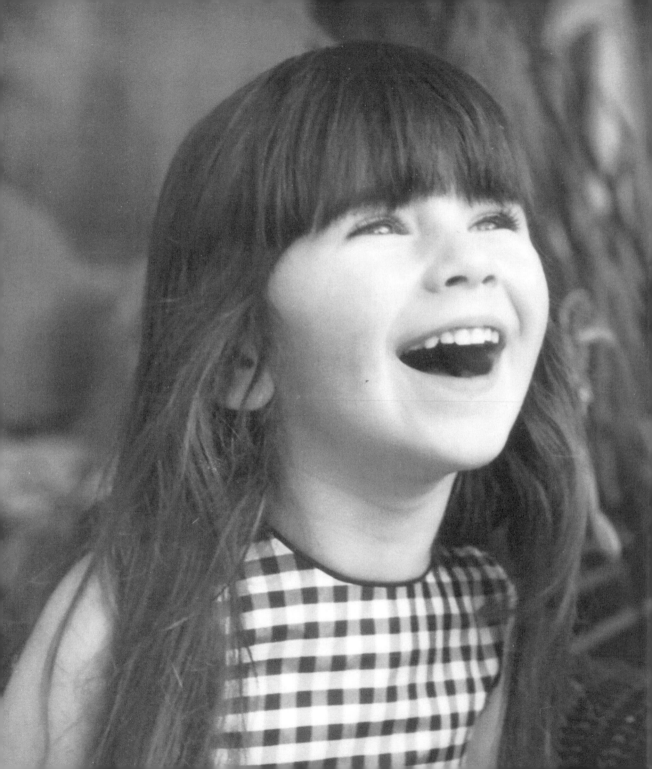

It is the child in us that loves.

[ANNE MORROW LINDBERGH]

Little children are the most lovely flowers
this side of Eden.

[REVEREND DR. DAVIES]

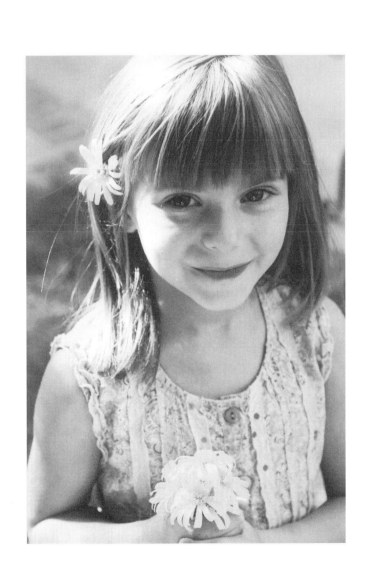

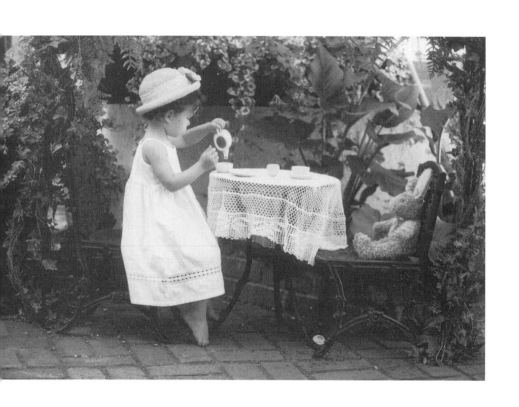

To little girls, tea parties are an essential part of the day.

A girl should be two things: classy and fabulous.

[COCO CHANEL]

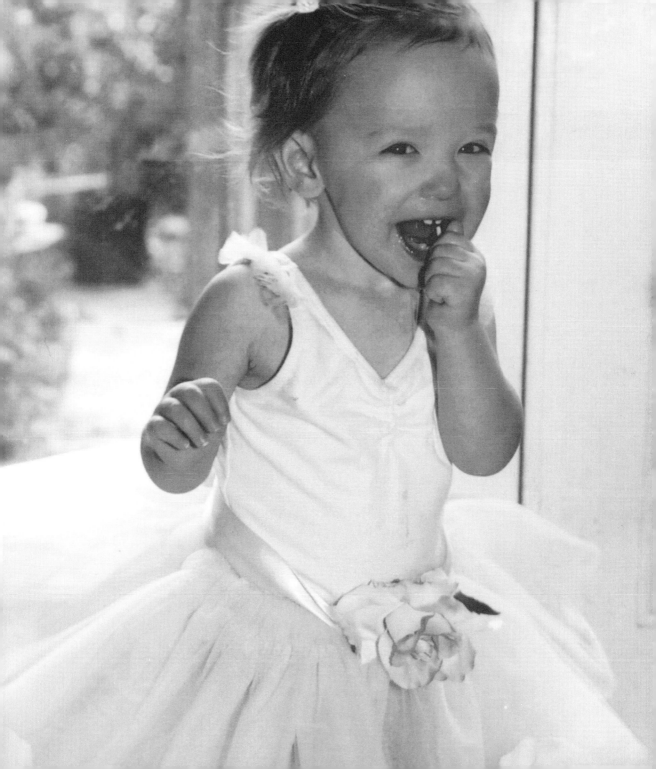

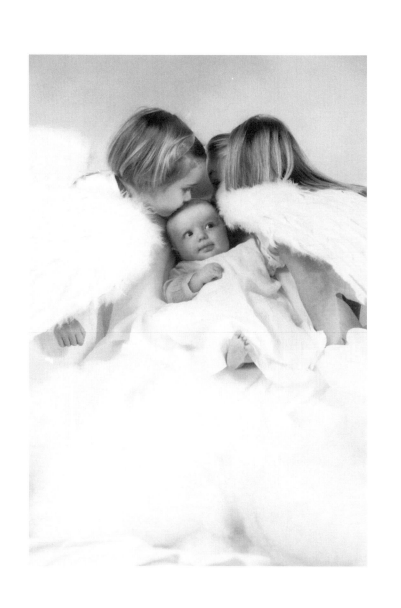

Only children still see an open door to heaven.

Thank heaven for little girls.

[ALAN JAY LERNER]

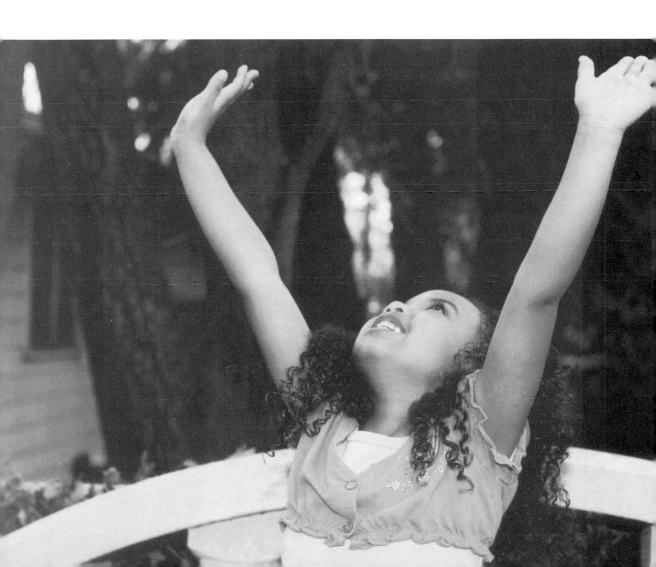

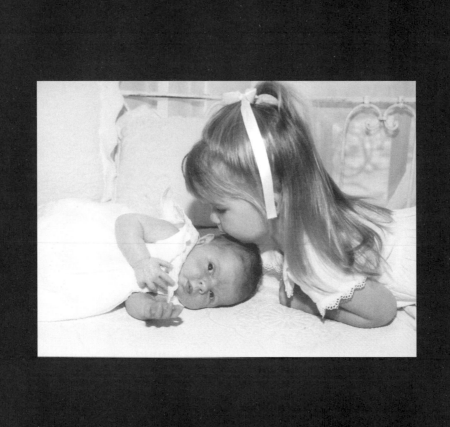